DRAWING BY STEALTH

Drawing by Stealth

John Trumbull and the Creek Indians

BY VIRGINIA POUNDS BROWN
AND LINDA MCNAIR COHEN

NEWSOUTH BOOKS
Montgomery

NewSouth Books
105 S. Court Street
Montgomery, AL 36104

Copyright © 2016 by Linda McNair Cohen. All rights reserved under International and Pan-American Copyright Conventions. Published in the United States by NewSouth Books, a division of NewSouth, Inc., Montgomery, Alabama.

Publisher's Cataloging-in-Publication data

Brown, Virginia Pounds
Drawing by stealth: John Trumbull and the Creek Indians /
Virginia Pounds Brown, Linda McNair Cohen.
p. cm.

ISBN 978-1-60306-363-0 (paperback)
ISBN 978-1-60306-423-1 (ebook)

1. Trumbull, John, 1756–1843. 2. Creek Indians. I. Title.

2016936471

Design by Randall Williams
Printed in the United States of America

To Ethel Mae 'Devil' Owen

Traveling with Devil is an adventure within itself. The road not taken that leads nowhere is her favorite road. She backs up with the same fierce velocity with which she goes forward. Accompanying these maneuvers is likely to be Pavarotti sobbing "I Pagliacci" at 18 decibels or the Sacred Harp sawing away at 15. No advice concerning directions and oncoming crash vehicles is expected or wanted.

But who else takes you where you want to go (and never stops for 1,000 miles).

— Virginia Pounds Brown

Table of Figures

Figure 1: *Washington at Verplanck's Point* / 5

Figure 2: *Washington and the Departure of the British Garrison from New York City* / 6

Figure 3: *Hopothle Mico* / 19

Figure 4: *Tuskatche Mico* / 21

Figure 5: *Stimafutchi* / 23

Figure 6: *John—A Creek* / 25

Figure 7: *Hysac* / 27

Contents

A Note about Spellings / ix

Why Trumbull? / 3

The Drawings / 17

A Question of Identity / 29

Bibliography / 39

With Gratitude / 44

A Note about Spellings

In this paper the Creek Indian names of people and places reflect the wrenching of Muskogean sounds into archaic French, Spanish, and English spellings over several centuries and thus into the research materials that scholars on the subject have left us.

While several notable Indians' names have variations in this paper, the authors wish to acknowledge in particular the many spellings of the Creek Indian towns with the name that survives today as Tallassee, an Alabama town that straddles the Tallapoosa River in Elmore and Tallapoosa counties.

In the seventeenth and eighteenth centuries, the Creek Indians who inhabited the area along the Chattahoochee, Coosa, and Tallapoosa rivers established towns that they named purposefully and systematically. Sometimes these names migrated with the populations. One such was Tallassee. The locations of the towns with the Tallassee-rooted name vary, too. One is even in Tennessee.

The name *Tallassee* is derived from the Muskogean words meaning "old town" and has been spelled in every possible phonetic way. For this paper, we tried to note the spelling we found in the source so that finding it again would be less of a challenge.

Among the spellings in the sources used are these:

Talasee—Fordham University; Irma Jaffe.
Talasi—Thomas McAdory Owen; Frederick Webb Hodge.
Talassee—Emma Lila Fundaburk; National Anthropological Archives, Smithsonian Institution; John Trumbull.

Tal-e-see—Benjamin Hawkins.

Talisi—W. Stuart Harris; Thomas McAdory Owen.

Tallasee—Amos J. Wright Jr.

Tallassee—Thomas McAdory Owen; Claudio Saunt; William Stokes Wyman in George Stiggins; Irma Jaffe.

Tallassie—John Walton Caughey; Irma Jaffe.

Tallesee – Irma Jaffe.

Tallisee—U.S. Government, Treaty of New York, transcribed documents, Charles J. Kappler.

Tulsa—John Reed Swanton

Further complications arise with letters that have evolved or gone missing from our alphabet. We were reminded by our editor, "I notice that 'Talasee King'. . . is actually written T-a-l-a-*-s-e-e, using the archaic long 's' where I have the asterisk. Which would make the spelling 'Talassee', not 'Talasee' as we have it."

However, Fordham, the institution that owns the drawing in Figure 3, has 'The Talasee (?) King' in their catalog entry. Knowing there are spelling variations helps with the search.

The languages of the Creeks and other Native Americans have greatly enriched the names on our contemporary maps, despite the occasional mangled spellings and mispronunciations by those unschooled in the vernacular. For further reading on Indian places and place names in Alabama, see the excellent *Historic Indian Towns in Alabama, 1540–1838* by Amos J. Wright Jr.

— LMC

Drawing by Stealth

Why Trumbull?

By what happenstance did John Trumbull, now famous for monumental canvases depicting American Revolutionary battles and leaders, come to draw five Creek Indians, pencil renderings, miniature in size? The answer appears to lie with George Washington and Trumbull's portrait of the president.

In 1790, Washington had invited a delegation of Creek Indians to New York City (then serving as temporary capital of the U.S.) to settle the dispute over Georgia's claim to Creek tribal lands. At the same time the Creeks were traveling to New York, Washington was sitting for his portrait.

Trumbull had recently finished a portrait of the president for Mrs. Washington [Figure 1] and had been commissioned by the City to produce a life-size version of the painting to hang in City Hall [Figure 2] to commemorate Washington's inauguration in New York in 1789.[1]

Trumbull described Mrs. Washington's portrait in an 1829 letter written to the painting's then owner, Mrs. Elizabeth Parke Custis, the granddaughter of Mrs. Washington and step-granddaughter of George Washington.

1 "Tobias Lear to Richard Varick, 19 July 1790," Note 1, Founders Online, National Archives (http://founders.archives.gov/documents/Washington/05-06-02-0042). Source: *The Papers of George Washington,* Presidential Series, vol. 6, 1 July 1790–30 November 1790, ed. Mark A. Mastromarino (Charlottesville: University Press of Virginia, 1996), 102–104.

> In the Summer of 1790, I painted a small whole length Portrait of General Washington, standing by a White Horse, leaning the right arm on the Saddle, & holding the bridle reins: in this picture not only the Head & Person of the General, but every part of the Dress, the Horse, & horse furniture were carefully painted from the real objects: the Background represents the encampment of the American Army at Verplanck's point on the North River in 1782: and the reception of the French Army on their return from Virginia, after the Capture of York Town: Stony Point, & part of the Highlands, and a glimpse of the North River, at the place where the Troops of France crossed, are seen in the distance.
>
> My name was inscribed near the bottom of the picture with the date 1790, where it may still be seen. And the picture was presented by me to Mrs. Washington, in evidence of my profound Respect.[2]

The second portrait, the one for the City, was to be similar to the first. Writing his autobiography in 1841, Trumbull recalled the City's portrait of the president.

> I was requested to paint for the corporation a full length portrait of the president. I represented him in full uniform, standing by a white horse, leaning his arm upon the saddle; in the background, a view of Broadway in ruins, as it then was, the old fort at the termination; British ships and boats leaving the shore, with the last of the officers and troops of the evacuating army, and Staten island in the distance. The picture is now in

2 Edgar P. Richardson, "A Penetrating Characterization of Washington by John Trumbull," *Winterthur Portfolio*, 3 (1967), 21. Letter from Trumbull in the Winterthur Museum, Joseph Downs Manuscript and Microfilm Collection.

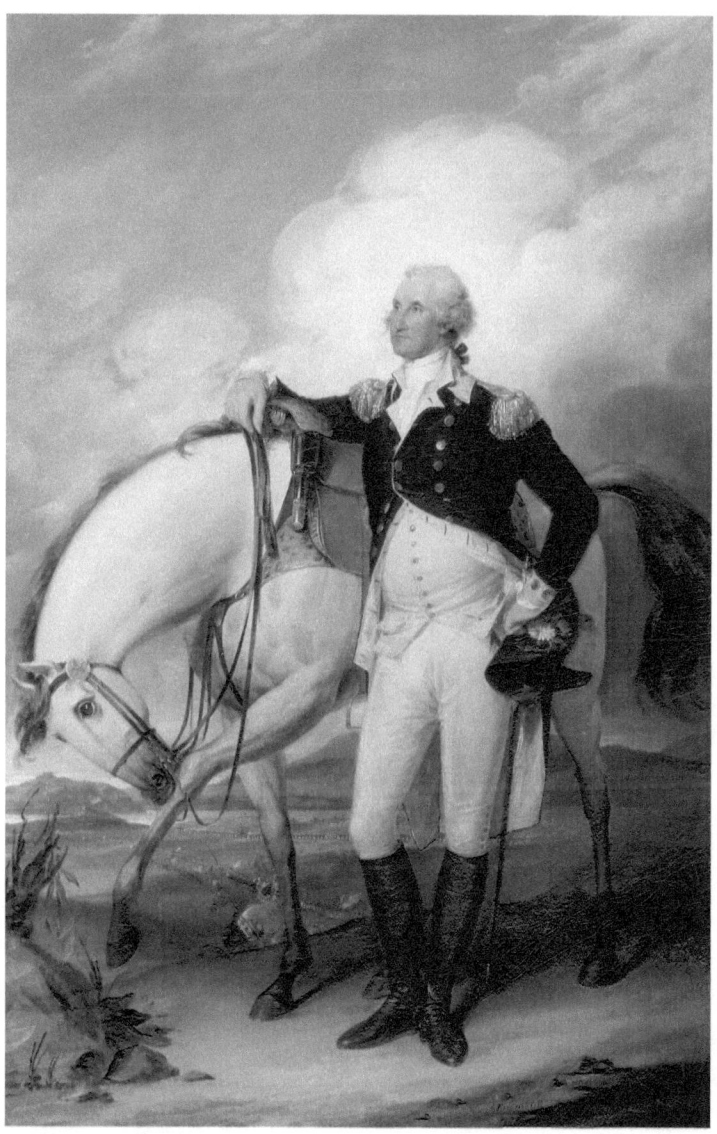

FIGURE 1

Washington at Verplanck's Point. New York, 1790. Oil on canvas, 20 x 30 inches. (Used with permission. Courtesy, Winterthur Museum.)

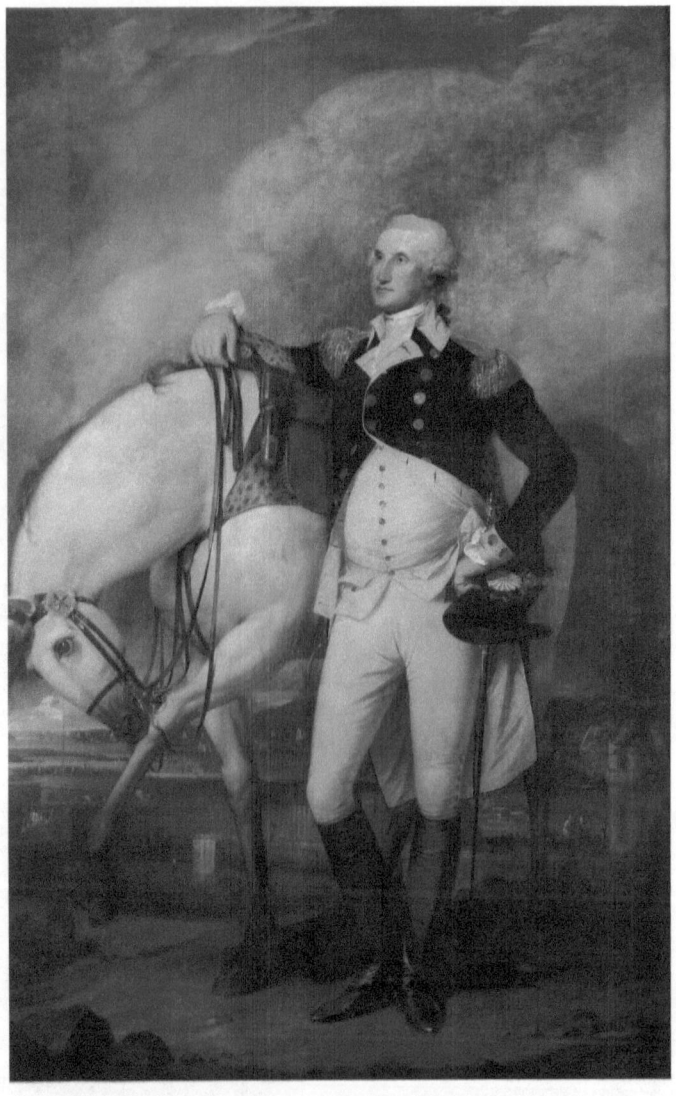

FIGURE 2
Washington and the Departure of the British Garrison from New York City. New York, 1790. Oil on canvas, 72 x 108 inches. (Used with permission. Collection of the City of New York. Photograph by Glenn Castellano, courtesy of the Design Commission.)

the common council room of the city hall. Every part of the detail of the dress, horse, furniture, etc., as well as the scenery, was accurately copied from the real objects.[3]

While Trumbull's descriptions suggest that the portraits are similar, the two paintings of the president and his horse are actually considerably different. As Trumbull notes, they are set against different backgrounds to commemorate different historic events, but what is most notable is that they are vastly different in scale. The second painting is more than three and a half times taller and wider than the first. For Trumbull, who excelled at small paintings, the achievement was significant.

Blind in one eye from a childhood accident, Trumbull had begun his career painting miniatures. He was excited over the commission for New York, as he revealed later in his autobiography. It was his first attempt at monumental portraiture. Triumphantly he wrote Benjamin West, his teacher in London, who thought Trumbull should be a miniaturist: "The figure is to be near seven feet high. It is to hang in the most elegant room in America [Federal Hall] and in a very perfect light."[4]

Five years earlier in London to study, Trumbull had turned his attention to painting the historic events of the American Revolution. In 1785 Thomas Jefferson, then minister to Paris from the United States, was in London to conduct political business and while there met Trumbull. Jefferson encouraged him to pursue the "great work," as Trumbull called his paintings of the American Revolution, and invited the artist to come to Paris to study and prepare. In 1789 with sufficient preparation and artwork to show for it, Trumbull

3 John Trumbull, *The Autobiography of Colonel John Trumbull, Patriot-Artist, 1756–1843*, ed. Theodore Sizer (New Haven: Yale University Press, 1953), 165–66.
4 Trumbull, ed. Sizer, 325–327.

traveled from London to America to seek funding for his national work. Many of the signers of the Declaration of Independence were in New York, and Trumbull hoped to sketch their faces from life for his unfinished canvases that were still in London.[5]

Trumbull was no stranger to Washington or to other notables gathered in New York for the convening of Congress in 1790. Ambitious and (some said) arrogant, Trumbull at age thirty-four had gained recognition as an artist and as a diplomatic courier between Jefferson in Paris and George Washington. He came from a distinguished New England family. His father, Jonathan, served as governor of Connecticut both when it was a British colony and later when it was a state. His brother Jonathan was the first congressman from Connecticut.

When the Revolutionary War started, Trumbull joined the Connecticut regiment and served as an aide to Washington, drawing battle plans. He had gained the rank of colonel by age twenty. When Congress failed to elect him a general (a rank he thought he deserved), he resigned and shortly thereafter left the United States to pursue a career as an artist. Contrary to the wishes of his father, who wanted him to be a preacher, and in spite of the war with Great Britain, he sailed to London to study painting with the foremost teacher of the day, Benjamin West. Now Trumbull had returned to New York, where he wrote, "All the world was assembled." The first Congress of the U.S. was in session and the city thronged with politicians, visitors, and diplomats from other countries.[6]

When the representatives of the Creek Nation arrived in New York City on July 20, 1790, a large crowd was on hand to greet the delegation. Kings, chiefs, and warriors splendid in their tribal adornments, stepped ashore. Twenty-six chiefs and their escorts had

5 Trumbull, ed. Sizer, 92–93, 163–70.
6 Trumbull, ed. Sizer, 163–66.

traveled, some on horseback, others in wagons and buggies overland, the thousand miles from the South. At Stone Mountain, Georgia, the Upper Creeks, from their towns on the Coosa, Tallapoosa, and Alabama Rivers, joined the Lower Creeks, from Coweta and Cussitah on the Chattahoochee River. They continued their journey together, stopping at Guilford Courthouse in North Carolina, site of a Revolutionary War battle, before pushing on to Richmond and Fredericksburg, Virginia. Finally they reached Philadelphia, and after a stay there, moved on to Elizabethtown Point, where they boarded the sloop that carried them around New Jersey's point into open sea and finally into the shelter of New York Harbor.

Along the way the Creeks had been greeted with curiosity and entertained as visiting dignitaries. George Washington followed their progress closely, concerned for their welfare. He wrote public officials of Virginia, Pennsylvania, and Maryland to show the Creeks "proper respect that they might be kept in good humor." He was particularly concerned with the well-being of Alexander McGillivray, a powerful influence of the Creek Confederacy, whose goodwill was also being sought by European powers. The president wished to impress McGillivray with the hospitality of the new nation.[7]

Fatigued as the Indians probably were, some even seasick from the last leg of the journey, they nevertheless donned ceremonial dress for their landing in New York. They were greeted by the Society of St. Tammany and escorted up Wall Street to Federal Hall where Congress was in session. After a short stop there, the procession continued to the president's house where Washington welcomed them briefly. Finally they arrived at the City Tavern for

7 "[July 1790]," Founders Online, National Archives, Saturday 3rd and Notes (http://founders.archives.gov/documents/Washington/01-06-02-0001-0007). Source: *The Diaries of George Washington*, vol. 6, 1 January 1790–13 December 1799, ed. Donald Jackson and Dorothy Twohig (Charlottesville: University Press of Virginia, 1979), 79–95.

a state dinner hosted by Secretary of War Henry Knox, in charge of U.S. Indian affairs, and George Clinton, governor of the state of New York.

When the dinner and the toasts were over, the Creeks retired to their assigned lodgings. McGillivray, never very healthy, went home with Secretary Knox, where he could enjoy the comforts he was accustomed to on his plantation in the Creek Nation. Other chiefs and headmen were lodged in an inn, while others stayed in tents outside the city.[8]

During the two months the Creeks had been traveling to New York, Washington had been sitting frequently for his portrait by Trumbull. The president's diaries during this period continue to reflect his concern for the traveling Creeks, particularly in light of reports that a plot by representatives of Spanish East Florida had threatened to undermine the pending negotiations.[9]

By late July the portrait was finished but not yet hung, and the Creeks, to Washington's relief, had arrived safely. Moreover, they became the toast of the town, as lavishly entertained as European dignitaries. When not meeting with government officials on tribal affairs, they were entertained at elaborate receptions and formal dinners. Abigail Adams, wife of vice president John Adams, found the Creeks—savages she called them—"fine looking men, placid

8 An important contemporary account of the Creeks' journey is in: William M. Willett, *A Narrative of the Military Actions of Colonel William Marinus Willett Taken Chiefly from his own Manuscript, Prepared by his son William M. Willett* (New York: Carvill, 1831), 94–113. Other contemporary accounts of the Creeks in New York are cited by: John W. Caughey, *McGillivray of the Creeks*, ed. William J. Bauer, Jr. (Columbia: University of South Carolina Press, 2007), 43; J. Leitch Wright, Jr. "Creek American Treaty of 1790: Alexander McGillivray and the Diplomacy of the Old Southwest," (*Georgia Historical Quarterly*, Vol. 51, December 1967), 379–80; Joseph J. Ellis, *American Creation: Triumphs and Tragedies at the Founding of the Republic* (New York: Random House, 2007), 153–159.

9 "[July 1790]," Founders Online, National Archives, Thursday 1st and Notes.

countenance and fine shape." She wrote her sister, "[they] are very fond of visiting us as we entertain them kindly. They behave with much civility."[10]

President Washington invited the principal chiefs to a dinner at his residence. As an after-dinner "entertainment," he arranged with Trumbull a showing of the newly completed portrait. As Trumbull writes, the president wanted to see its effect on their "untutored minds."[11] The large size of the portrait would have caught even the *most* tutored of minds of the day off guard. In 1790 the average height of a man was about 5'8". Washington was by all accounts a big man at 6'2" tall, weighing about 220 pounds. He was neither portly nor gangly but imposing and is said to have possessed the graceful carriage and posture of the expert horseman that he was. Outfitted that evening in full military dress he would have seemed larger than life and made an impression on anyone in his presence. Seeing this elegant leader and his life-size portrait at the same time could possibly have impressed even the crowned heads of Europe.

Trumbull, writing fifty years later in his autobiography, recalls the occasion from his perspective.

> [The president] directed me to place the picture in an advantageous light, facing the door of the entrance of the room where it was. . . . He, after dinner, proposed to [the chiefs] a walk. He was dressed in full uniform, and led the way to the painting room, and when the door was thrown open, they started at seeing

10 "Abigail Adams to Mary Smith Cranch, 8 August 1790," Founders Online, National Archives (http://founders.archives.gov/documents/Adams/04-09-02-0046). Source: *The Adams Papers, Adams Family Correspondence*, vol. 9, January 1790–December 1793, ed. C. James Taylor, Margaret A. Hogan, Karen N. Barzilay, Gregg L. Lint, Hobson Woodward, Mary T. Claffey, Robert F. Karachuk, and Sara B. Sikes (Cambridge: Harvard University Press, 2009), 84–86.
11 Trumbull, ed. Sizer, 163–67.

another 'great Father' standing in the room. One was certainly with them, and they were for a time mute with astonishment. At length one of the chiefs advanced towards the picture, and slowly stretched out his hand to touch it, and was still more astonished to feel, instead of a round object, a flat surface, cold to the touch. He started back with an exclamation of astonishment.... Another then approached, and placing one hand on the surface and the other behind, was still more astonished to perceive that his hands almost met.[12]

Were the Indians as astonished by this experience as Trumbull would suggest? Or were they just going along with the game? In the eighteenth century the Creeks had already had dealings with the English, French, and Spanish for trade and alliances and with Georgia for diplomatic affairs and land interests. They were not strangers to the customs and behaviors of their hosts. These particular Indians had traveled from Georgia to New York by way of the Carolinas, Virginia, Maryland, and Pennsylvania, and in all places had been honored and entertained as guests by officials and dignitaries as well as the president's sister, Mrs. Betty Lewis.[13] For almost two weeks they had been in New York, attended events, and been feted by the city's finest. While we do not know exactly what sights were before them, we must consider that they had not been blindfolded all this time. No, these were chiefs who had arrived at this place in time by their birth, ability, and training. They were experienced.

Trumbull, obviously interested in them, had confided to Abigail Adams earlier that many of the Creeks were perfect models. He recalls, "I had been desirous of obtaining portraits of some of

12 Trumbull, ed. Sizer, 163–67.
13 Willett, 111–12.

these principal men, who possessed a dignity of manner, form, countenance and expression, worthy of Roman senators, but after this [viewing] I found it impracticable; they had received the impression, that there must be magic in an art which could render a smooth flat surface so like to a real man; I however succeeded in obtaining drawings of several by stealth."[14]

Perhaps Trumbull expected the Creeks to react as scared or awestruck by his artistic "magic" so that he felt compelled to sketch them surreptitiously. Or did he later recall the event so that it made a better story? Without Washington's account—the president's records of this time as far as scholars know have not survived—we have only Trumbull's somewhat self-serving tale.

Although the precise circumstances of when and where Trumbull made the drawings are not known, they are dated July 1790, just prior to the signing of the treaty. On August 7 the Creeks, the full-bloods in tribal regalia, assembled in Federal Hall for the signing of the Treaty of New York. A large crowd of spectators joined the Indians and high-ranking officials of the U.S. Government for the colorful ceremony which lasted most of the day. Each clause of the treaty was read aloud, first in English and then in Creek. George Washington and Henry Knox, Secretary of State, signed for the United States. Alexander McGillivray signed first for the Creeks, followed by twenty-three delegates (some of the original party may have defected[15]) from the Creek Nation who added "x's" to their marks. Gifts were exchanged, the peace pipe was smoked.[16] The next day Abigail Adams wrote, "Yesterday

14 Trumbull, ed. Sizer, 163–67.
15 Wright, 393.
16 Caughey, 278; Ellis, 158, et al. A description summarizing contemporary accounts of the events may be found in the notes on http://founders.archives.gov/documents/Adams/04-09-02-0046 and also http://founders.archives.gov/documents/Washington/05-06-02-0084-0001

they signd the Treaty, and last Night they had a great Bond fire dancing round it like so many spirits hooping, singing, yelling, and expressing their pleasure and Satisfaction in the true Savage Stile."[17]

The Creeks, with their signing of the Treaty of New York, ceded tribal land for the first time—only a bit at the beginning. But after McGillivray's death in 1793, the Creek Nation was doomed before the determined and growing power of the United States. Washington's hope that Indians and whites would live peacefully side by side came to naught.[18]

When the United States capital moved from New York to Philadelphia in 1791, Trumbull followed and opened his studio there. Subsequently he painted miniatures of three Indians from the northeast tribes. But historical paintings, the most famous of which are the four paintings encircling the dome of the U.S. Capitol, make up the bulk of his work.

First published in Trumbull's autobiography in 1841, the sketches of the Creeks received wide attention as a valuable source of Southeastern Indian portraiture when they appeared in John Swanton's book *The Indians of the Southeastern United States*, published in 1946.[19] Trumbull provides the only known mention of the possible happenstance by which he came to draw the five Creeks.

17 Adams to Cranch, Founders Online.
18 The Creeks did not come away from New York empty-handed. A secret article added later to the treaty appointed "great medal chiefs" who would receive peace medals and $100 annually for themselves and other "beloved men of their towns." Another secret article named McGillivray as a special U.S. agent to the Creeks, with a commission as brigadier general and an annual stipend of $1200. Washington had hoped to bind the Creeks closer to the U.S. with these concessions and break their ties with Spain and Great Britain. http://funders.archives.gov/documents/washington/05-06-02-0122
19 *Smithsonian Institution Bureau of American Ethnology Bulletin 137* (Washington: GPO, 1946).

Washington's record of the event—if he made one—has been lost with all of his diaries from the period between July 15, 1790 and March 20, 1791.[20]

Under what particular circumstances and behind what veil of secrecy Trumbull worked we can only imagine. To us the five portraits of the Creeks appear more like well-executed drawings than sketches hastily and furtively dashed off. The attention to detail is remarkable. They are sensitive renderings and show the artist's ability to capture personality in his subjects. Whether by consent or stealth, by foul means or fair, Trumbull recorded and preserved a piece of American history and Alabama heritage.

20 Lear to Varick, note 2, Founders Online.

The Drawings

Trumbull, according to art critics, had an exceptional ability to capture a sense of personality in his portraits. This is clearly evident in the Creek drawings[21] that he made in the summer of 1790. They reflect Trumbull's feelings about Native Americans.

He confessed to a lifelong interest in Indians. As a child, he had been moved by the eloquence of a Mohegan chief dining at his father's table. Contrary to the prevailing sentiment of the day, he says, he grew deeply sympathetic to the struggle of Indian nations. [22]

Unfortunately, Alexander McGillivray, of whom there is no known likeness, is not one of Trumbull's five sketches. Trumbull makes no mention of him. Washington is silent. Perhaps McGillivray appeared too much like a white man to attract Trumbull's pencil. Abigail Adams, writing in 1790 after seeing McGillivray, says: "[McGillivray] speaks English like a native [meaning, like a white man]. I should never suspect him to be of that nation, as he is not very dark."[23] Moreover, much of the time while in New York, McGillivray was ill, "seized with a violent indisposition."[24] In all likelihood, when Trumbull was drawing, McGillivray was in quarters.

21 Engravings of the drawings appear following page 164 of the first edition: John Trumbull, *Autobiography, Reminiscences and Letters of John Trumbull, from 1756 to 1841* (New Haven: B.L. Hamlen, 1841).
22 Trumbull, Sizer, ed., 7–8.
23 Adams to Cranch, Founders Online.
24 Caughey, 279.

"Hopothle Mico, the Talasee King of the Creeks"

Hopothle Mico[25] [Figure 3] was one of the "kings" noted arriving in New York harbor in 1790.[26] He is found on the Treaty of New York as Hopothe Mico. A powerful leader of the Upper Creek town Tallassee, located on the Tallapoosa River in Alabama, he drew many followers and his favor was sought by Spain, France, Britain, and the United States. He sided with the British in the Revolutionary War and with revolting Creeks against the U.S. in the Creek Indian War. In 1809 he reminded President James Madison of the Creeks' 1790 treaty with the U.S.: "the Muscogee land is become very small. It is become small and we hope there will be no more encroachments on us. . . . Our agreement was plain."[27] Hopothle Mico's expression, almost sorrowful, conveys the strength and anguish of a chief torn by challenges to the old ways.

Hopothle Mico is a striking figure arrayed in trade goods and native adornments. His military coat is most likely a gift from the U.S. even though France, Britain, and Spain also presented coats to the Indians. His turban, a favored headdress for the Creeks, appears to be of trade cloth, probably red. Tufts of egret feathers are inserted into his earlobes. The egret was sacred to Indians. Trade beads encircle his neck. The crescent-shaped gorget, likely silver,

25 Also Hopothe Mico, Hobohoilthle, and other spellings.
26 Called the Tame King of Tallassee, in the 1780s and 1790s he made efforts to live in peace with Americans but later criticized encroachment on traditional Creek land and spoke on behalf of the national council of the Creek Confederation. Angie Debo, *The Road to Disappearance* (Norman: University of Oklahoma Press, 1967), p. 75; James F. Doster, *The Creek Indians and Their Florida Lands, 1740–1823* (New York: Garland, 1974), 2:12–18.
27 "To James Madison from Hobohoilthle, 29 September 1809," Founders Online, National Archives (http://founders.archives.gov/documents/Madison/03-04-02-0656 [last update: 2015-06-29]). Source: *The Papers of James Madison*, Presidential Series, vol. 4, 5 November 1811–9 July 1812 and supplement 5 March 1809–19 October 1811, ed. J. C. A. Stagg, et al. (Charlottesville: University Press of Virginia, 1999), 605–607.

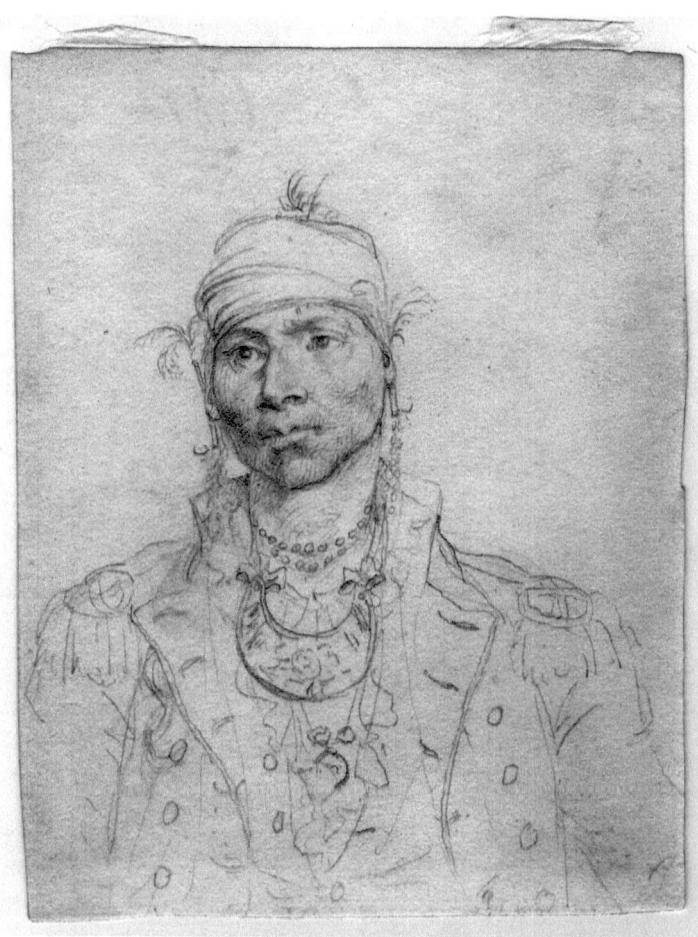

FIGURE 3

Hopothle Mico. Inscription on back of drawing: Hopothle Mico or / the Talasee King / N York July 1790. Pencil sketch on paper, 3⅞ x 5 inches. (Used with permission, Charles Allen Munn Collection, Fordham University Library, Bronx, New York.) Reproduced as Pl. 21 in Trumbull autobiography with caption "Hopothle Mico—or the Talassee King of the Creeks—JT—New York 1790."

may be a gift from the U.S. or a foreign government. Gorgets were highly prized by the Indians as symbols of power. Further marking Hopothle Mico's importance is a lock of hair attached to his coat, possibly belonging to a former chief. He was awarded a peace medal at the signing ceremony of the Treaty of New York.[28]

"Tuskatche Mico, or the Birdtail King of the Cusitahs"

This chief's name appears on the Treaty of New York as Fuskatchee Miko [Figure 4] or Fuskatche Mico.[29] Also called Birdtail King or White Tail King, Chief of the Cusitahs (Kasihta), he represented the Lower Creek towns of the Confederacy. Fuskatchee Mico's signature (X mark with title) appears on the treaty immediately below that of McGillivray, an indication of his high position. He also received a peace medal at the signing.[30] The peace for the Bird Tail King was uneasy. "The Bird-tail king and eight of his town were most treacherously attacked by a party of whites, about fifteen miles on the other side of the Oconee, and two of their number killed. . . . [They] were hunting on their own lands, under the assurance of safety pledged to them."[31]

When the Creeks met at Colerain in 1796 with three federal commissioners and a Georgia commission determined to get more tribal land, Fuskatchee Mico spoke for the Creek Nation. His

28 "Proclamation, 14 August 1790," Founders Online, National Archives (http://founders.archives.gov/documents/Washington/05-06-02-0122) [last update: 2015-06-29]. Source: *The Papers of George Washington*, Presidential Series, vol. 6, *1 July 1790–30 November 1790*, ed. Mark A. Mastromarino (Charlottesville: University Press of Virginia, 1996), 248–254.

29 Also Fushatchee Mico, Fusatchee Mico, and other spellings. *Indian Affairs: Laws and Treaties*, Charles J. Kappler, comp. and ed. (Washington: GPO, 1904), 28.

30 Proclamation, 14 August 1790.

31 American State Papers, 3rd Congress, 1st Session, Indian Affairs, vol. 1, 472–474. *Letter from Constant Freeman to the Secretary of War.*

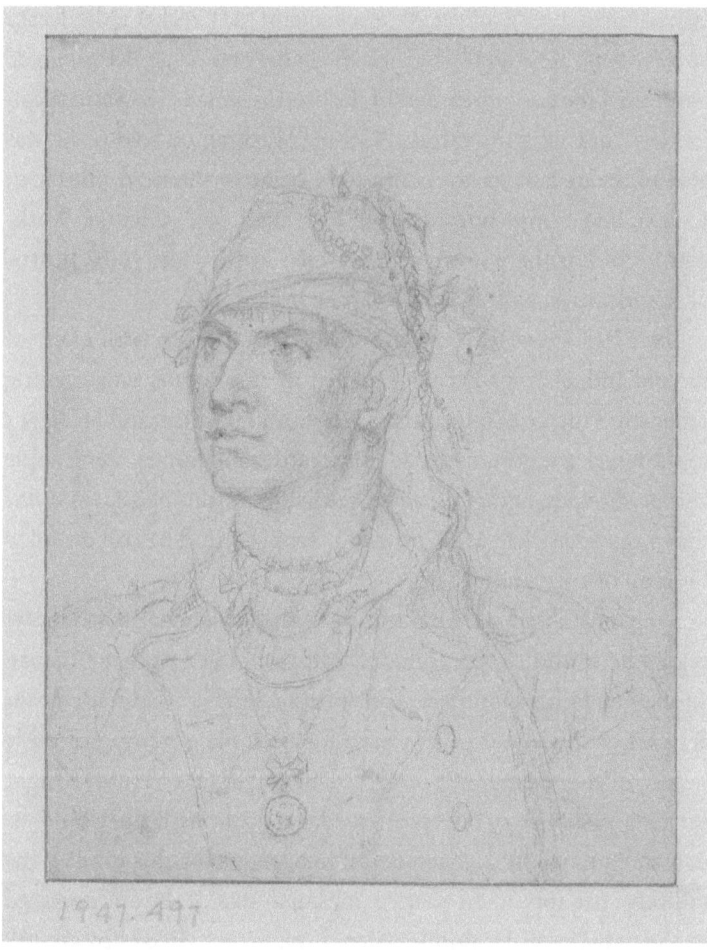

FIGURE 4

Tuskatche Mico. Pencil sketch on paper, $3^{11}/_{16}$ by $4^{11}/_{16}$ inches; interleaved in a copy of 1905 edition of Trumbull autobiography; verso inscription, if any, unknown. (Used with permission, Beinecke Rare Book and Manuscript Library, Yale University.) Reproduced as Pl. 22 in Trumbull autobiography with caption "Tuskatche Mico, or the Birdtail King of the Cusitahs, N. York July 1790—J. T."

impassioned speech reflected the reliance of the Creeks on the Treaty of New York. Repeatedly he used the name of George Washington, reminding the commissioners of the promises made by Washington in New York six years earlier. "George Washington told us he was glad to see us face to face. 'You have come to the head, the main branch, and I hope our talks will be straight.' . . . George Washington told us there was a chain riveted in [his] and [our] hearts, of friendship so strong as never to be broken."[32]

By 1799, however, Fuskatchee Mico had broken with many of the old Indian ways and had turned to agriculture, encouraging other tribesmen to do the same. Benjamin Hawkins, Indian Agent to the Creeks, reported he had hogs, cattle, and horses, some apple and peach trees, and grapevines. Earlier, Hawkins had spent a day showing Fuskatchee Mico how to use a plow, and he had doubled his crop of corn and potatoes.[33]

The most distinguishing feature of the Fuskatchee Mico drawing is the strand of hair, braided halfway, pulled over the turban and falling to his shoulders. Tufts of egret feathers and trade beads are part of the headdress. Around his neck hang a string of trade beads, an engraved gorget, and a small gorget that Vernon Knight suggests could be a European medal or coin as both would be consistent with the archaeological knowledge for this time.[34] The military coat appears to be the same cut as that of the one depicted in the drawing of Hopothle Mico. Fuskatchee Mico's lips are full and his neck long, both said to be Creek characteristics, and his expression inquiring and resolute.

32 American State Papers, Senate, 4th Congress, 2nd Session, Indian Affairs, vol. 1, 599–600. Quoted in part.
33 Benjamin Hawkins, *Creek Confederacy and a Sketch of the Creek Country* (Savannah, 1848), 60.
34 Vernon J. Knight, letter to the author, April 18, 2014.

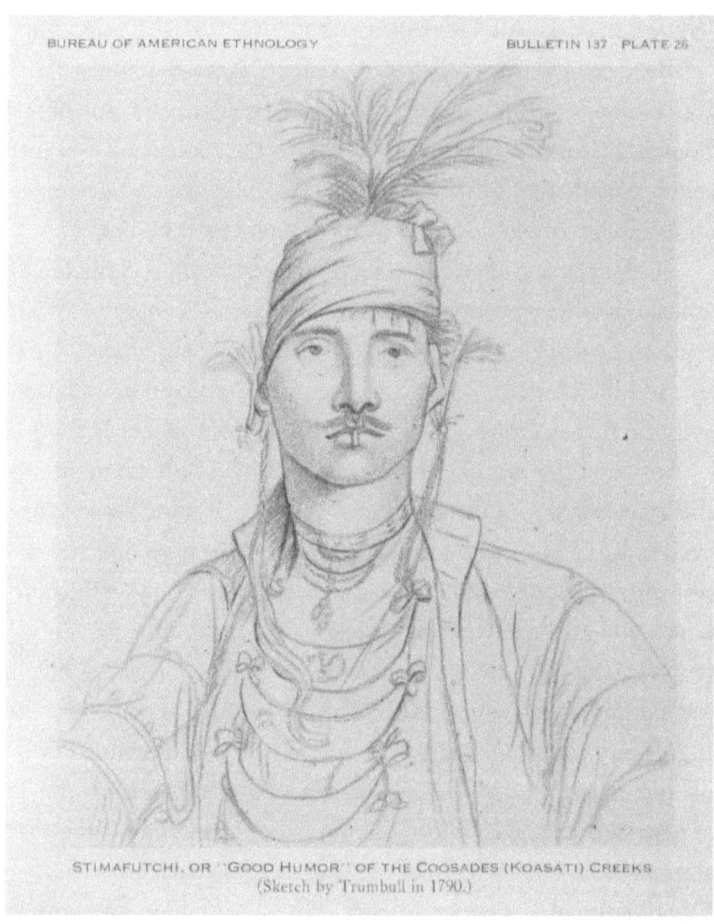

FIGURE 5

Stimafutchi. Original lost. Reproduction from *Bulletin*, Smithsonian Institution, Bureau of American Ethnology. 1946. No. 137. Pl. 26. (Biodiversity Heritage Library. http://www.biodiversitylibrary.org/bibliography/37959, accessed 29 April 2014. Used without restrictions.) Reproduced as Pl. 20 in Trumbull autobiography with caption "Stimafutchki, or Good-Humor—of the Coosades, Creeks, New York July 1790 J.T."

"Stimafutchi, or Good Humor"

The drawing of Stimafutchi[35] [Figure 5] leaves no doubt of his high rank or of his inheritance. Trumbull titles him as being of the Coosades (Koasati) Creeks, who lived on the Alabama River, just below the junction of the Coosa and the Tallapoosa. His name is on the Treaty of New York with the epithet Good Humor.

The four large gorgets and other trade goods worn by Stimafutchi indicate a long association of his people with the European powers, beginning with De Soto in 1540, followed by Spain, France, Britain, and the United States. The top gorget appears to be engraved with the British crown.

Stimafutchi wears a cloth turban with feathers tucked in the top and egret feathers in the upper ears. A string of trade beads hangs from one ear. The most unusual features are the nose ring and the labrum (lip) ring. Beads such as these, often cobalt blue in color, were trade goods secured by the French from the Russians; they were favorite trade items of the French with the Creeks. While it was said by one observer that the wide necklace is made of rectangular stones, Knight says that this cannot be determined from the picture and adds, "that description does not match any article of personal adornment I know about from the period."[36] The coat appears to be French, as does the small bead necklace.

Stimafutchi is a striking figure. His heavy-lidded eyes appear to be focused on a distant object.

"John, a Creek"

The expression of John [Figure 6] is in sharp contrast to Stimafutchi's. He seems to be smiling almost self-consciously, eyes averted, purposefully looking away. He does not have the rank of

35 Also Stimafutchki, Stimafutchee, and other spellings.
36 Knight, letter.

FIGURE 6
John—A Creek. Pencil sketch on paper, approximately 4 x 5 inches; interleaved in a copy of 1905 edition of Trumbull autobiography; verso inscription, if any, unknown. (Used with permission, Beinecke Rare Book and Manuscript Library, Yale University.) Reproduced as Pl. 18 in Trumbull autobiography with caption "John—a Creek—N. York—July 1790—J.T."

the previously discussed Creeks (he does not wear a gorget), but his unusual headdress could have attracted Trumbull. Most striking is the ornament secured in his turban and hanging on his forehead. Egret feathers sprout from the top of his head and his ears. One plait of hair falls over his forehead, another plait to the side. He wears a nose ring similar but not identical to Stimafutchi's. The necklace of trade beads, some elongated, resembles Stimafutchi's.

"Hysac"

Hysac [Figure 7], titled by Trumbull "the woman's man," appears effeminate. His expression is languid. The two gorgets he wears mark him as a person of importance in the tribe. The smaller gorget appears Spanish; the lower one may be native. The nose ring is probably bone.

Engravings of the five drawings were produced by Daggett, Hinmann & Co. and published in Trumbull's 1841 autobiography. In 1946 Swanton reproduced the images from engraver plates, but the captions for Hysac and John were transposed.[37] In her catalog of Indian portraits, Emma Lila Fundaburk reproduced three images from the original drawings and two from the Smithsonian's negatives from the Bureau of American Ethnology. She also corrected the error of the transposed captions in Swanton.[38]

37 Pl. 33.
38 Emma Lila Fundaburk, *Southeastern Indians Life Portraits: A Catalogue of Pictures 1564–1860* (Luverne, AL: 1958), 55, 116.

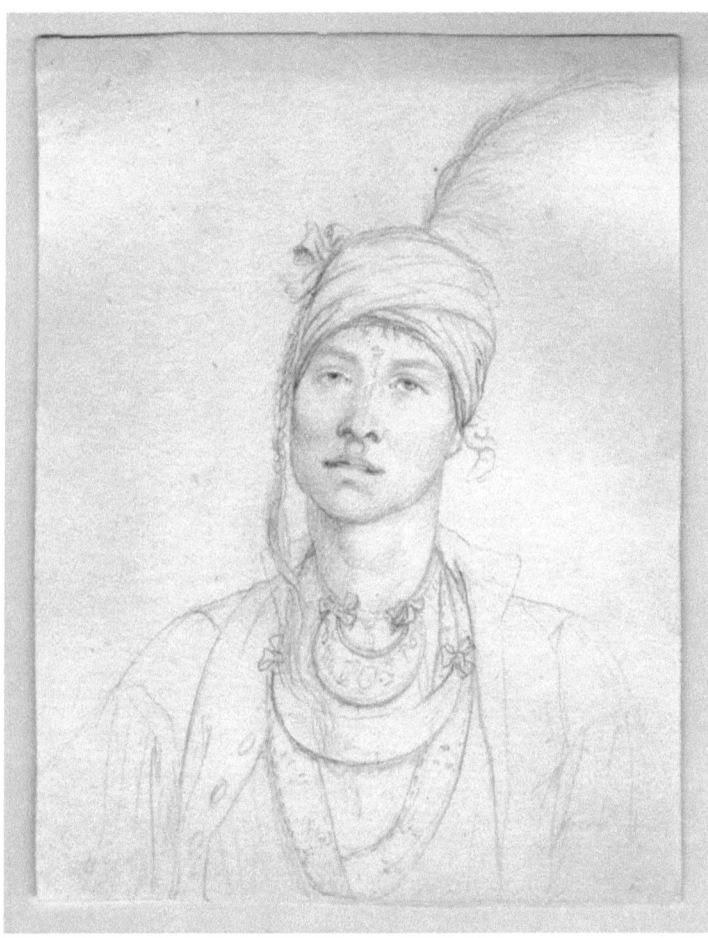

FIGURE 7

Hysac. Inscription on back of drawing: Hysac or / The Woman's Man / N York July 1790. Pencil sketch on paper, 3⅞ x 4⅞ inches. (Used with permission, Charles Allen Munn Collection, Fordham University Library, Bronx, New York.) Reproduced as Pl. 19 in Trumbull autobiography with caption "Hysac, or the Woman's Man N. York July 1790—J.T."

A Question of Identity

Archivists, librarians, researchers all dream of finding buried treasure. In 1943 Fordham University received a gift of thirty-five drawings by John Trumbull. Included in the gift were several drawings that had been classified as "unlocated" in Theodore Sizer's extensive and authoritative checklist of Trumbull's works.[39] For most institutions, finding the missing art would be a prize in itself, but imagine the excitement of Dr. Irma Jaffe, an art historian at Fordham, when the rediscovered drawings demonstrated the potential to solve mysteries, unlock secrets, or break new ground. A skilled academic, Jaffe discovered clues to hidden and mistaken identities in Trumbull's paintings, notably in his familiar masterpiece *The Declaration of Independence* (engraved on the two-dollar bill), but also in Trumbull's historical, religious, literary, landscape, and figurative work.[40]

Included in the Fordham gift was a small pencil sketch, only 3⅞ by 5 inches, of a Creek Indian man. Penciled on the back of this sketch are the words: *Hopothle Mico or / The Talasee King / N York July 1790* [Figure 3]. In her research, Jaffe poses a tantalizing possibility and suggests: "This study of an Indian Chief confronts us with a surprising possibility and a vexing question. The problem concerns the identity of the subject of our portrait, and requires a

39 Theodore Sizer, *The Works of Colonel John Trumbull*, revised edition (Yale University Press, New Haven, 1967).
40 Irma B. Jaffe, "Fordham University's Mistaken Identities in 'The Declaration of Independence' and Other Discoveries," (*American Art Journal* 3, Spring 1971), 5–38.

two-pronged exploration. First, has Hopothle Mico come down to us in history under another name—a very unlikely name for an Indian chief—under the name, that is, of Alexander McGillivray, the man who negotiated and signed on August 7, 1790, the Treaty of New York, the first treaty between the United States and the Creek nation; secondly, is this drawing in fact a portrait of Hopothle Mico?"[41]

To claim the identity for McGillivray, Jaffe uses the circumstances of the treaty, personal names, place names, subjectivity, and a reliance on what some scholars call "Old Indian history." Having laid out her argument, she concludes by stating, "I do believe we have found the only portrait in existence of an important figure in American history, that strange and remarkable 'Good Child King,' Alexander McGillivray."[42] This conclusion is incorrect.

Jaffe's research findings do not reverse the long-held statement made by McGillivray's biographer, John Caughey, who wrote in 1938: "To the best of our knowledge, no likeness of McGillivray exists."[43]

Jaffe's investigation misled her to a conclusion that has migrated into the realm of the sort of "facts" that become facts if they are repeated often enough. The portrait is now widely reproduced and incorrectly identified as that of Alexander McGillivray. For the entry on McGillivray in the online *Encyclopedia of Alabama*, Andrew Frank writes: "Although there is an early drawing that has been widely circulated as being a depiction of McGillivray, many scholars believe that it is unlikely to be him."[44]

The correct conclusion is that the early drawing is in fact of *Hopothle Mico, the Talasee King*, just as Trumbull noted. Like

41 Jaffe, 14–15
42 Jaffe, 19.
43 Caughey, 3.
44 http://www.encyclopediaofalabama.org/face/Article.jsp?id=h-2313

McGillivray, Hopothle Mico was in New York in 1790 when the Creek delegation signed the treaty with the U.S. and when Trumbull made his drawings of the five Creek Indians.

Jaffe is a scholar in art history and an authority on Trumbull. Her analysis of this drawing is intriguing but resulted in error because of the complications of Indian history, personal names, and place names.

Old Indian History

As William Bauer explains in his introduction to a new printing of John Caughey's *McGillivray of the Creeks*, "Old Indian history" is written from a Euro-American perspective, whereas later scholarship attempts to use anthropology, historical records, and research to understand both sides of the cultural encounter between natives and newcomers. Jaffe leans on the "Old Indian history" that paints McGillivray as a super-heroic figure, the soul of the Creek nation, the Talleyrand of Alabama, and the preeminent leader of the chiefs who were invited to New York. While it is true that McGillivray paved much of the Creeks' path to this place in time, the way was not without potholes and dead ends. Bauer summarizes the twentieth-century debate on whether McGillivray was altruistic for the Creeks or avaricious for himself: "McGillivray was probably something in between 'the genius diplomat' that Theodore Roosevelt described and the destructive influence that [Claudio] Saunt discovers."[45]

New perspectives tell us that the Creeks were not one nation solidly united under McGillivray, nor were they of one mind in regard to their relationships with the incomers to their territory. Within the confederacy of Creek towns were dissenters and adversaries who questioned McGillivray's motives, were suspicious of his dealings, and sometimes engaged in their own negotiations with whites.

45 Caughey, xxi.

This dissension is important because one of McGillivray's known and abiding adversaries was the Tallassee King, Hopothle Mico.

Michael Green provides background for the conflict, saying that it dated to the Revolutionary War and was provoked by clan rivalry. There were opposing negotiations, name calling, and the threat of force.[46] McGillivray described Hopothle Mico as "a roving beggar, going wherever he thinks he can get presents."[47] Saunt says that after the Revolutionary War, social and economic upheaval began to split the Creeks into those who wanted the new market-based society and those who did not. Mestizos like McGillivray were comfortable dealing in the language and commodities of the European trade, including slaves, while traditional Creeks were not. Saunt writes: "Hoboithle Micco [Hopothle Mico], who rose to power as a great speaker and as the son of the Old Tallassee King, disapproved of these latecomers whose status depended on wealth." Those who opposed McGillivray looked to Hopothle Mico. He and McGillivray were in continuous dispute over land cessions that Hopothle Mico and other chiefs made to Georgia. Saunt suggests that the clash between the two went beyond the treaties and was rooted in ethnic and linguistic differences among the Creek clans. The enmity lasted until McGillivray's death in 1793. The residuals of their conflict may have helped to kindle the Redstick War.[48]

This glimpse of their shared history shows that McGillivray and Hopothle Mico were two different men with strongly conflicting opinions and missions. Their identities should not be confused.

46 Michael Green, "Alexander McGillivray," in *American Indian Leaders: Studies in Diversity.* Russell David Edmunds, ed. (Lincoln: University of Nebraska Press, 1980, 41–63), 49–53.
47 Caughey, 103.
48 Claudio Saunt, *A New Order of Things: Property, Power, and the Transformation of the Creek Indians, 1733–1816* (Cambridge: Cambridge University Press, 1999), 62–63, 79–83, 87.

The Treaty of New York

Jaffe writes: "The terms of the treaty do not concern us here, except for one possibly significant detail: Alexander McGillivray was made a Brigadier General at this time."[49] Focusing on the military-style coat worn by the individual in the drawing, she describes the epaulettes as like those on the coat Trumbull had painted in his portrait of a known brigadier general. Thus, she determines the man in the apparent brigadier general's coat must be McGillivray. The fabric of her evidence is thin. To begin with, the drawing is not a photograph. We do not know the origin of the coat. We do not know if Trumbull drew the coat as he saw it or as he remembered it. Also, instead of dismissing the treaty, we should consider it, particularly because of this reliance on the coat as evidence. We do know that governments gave military coats as gifts to Indians and that McGillivray may have received the coat of a brigadier general with his commission, but his commission was made in Article Three of *six secret articles*, unseen and unsigned by the twenty-three other chiefs and not made known until after the treaty's proclamation on August 14.[50] Wearing such a coat beforehand in July is implausible.

Indian Names

Jaffe deduces from various sources how McGillivray's Indian name could actually have been Hopothle Mico.[51] On this path she treads an obstacle course of variant spellings and transliterations. She begins with John Pope's account of time spent with the Creeks in 1791, the year after the treaty was signed. Pope heard the name Hippo Ilk Meco, the Good Child King, probably in regard to McGillivray. Caughey's variation of this name is Hoboi-Hili-Miko,

49 Jaffe, 17. Text and footnotes.
50 Proclamation, 14 August 1790.
51 Jaffe, 17–18.

the Good Child King.⁵² John R. Swanton affirms that Hoboi-hili miko would be the correct Creek for Hippo Ilk Meco, but adds that McGillivray did not qualify as a mico.⁵³ Saunt suggests that McGillivray "may not even have had a Muskogee name."⁵⁴

Jaffe concludes incorrectly that Hopothle Mico and Hippo Ilk Meco are the same person and then refers to the published treaty for the names of those who signed it. Both McGillivray and Hopothle Mico signed. McGillivray, the first to sign, wrote "Alexander McGillivray" with his L.S. [*Locus sigilli*, the place of the seal] "in behalf of themselves and the whole Creek nation of Indians." Underneath his signature, the twenty-three Creek chiefs made their marks next to the designations for their towns with their marks. As the Creek chiefs did not write in English, their names and tribes were spoken and would have been transcribed by a clerk. The names that are written on the treaty are transliterations and variant spellings. Hopothle Mico, Tallassee King was written Hopothe Mico, Tallisee King. He made his mark on the treaty under the designation for Big Tallisee.⁵⁵

Jaffe allows that there were two individuals with similar Creek names, but she reasons that their epithets set them apart. As she has

52 Caughey, 3.
53 *Social Organization and Social Usages of the Indians of the Creek Confederacy.* Smithsonian Institution Bureau of American Ethnology, 42nd Annual Report (Washington: GPO, 1928), 324. Green explains that many of the Creek micos (kings) interacted with McGillivray as if he were a mico, but he did not presume the title. He functioned as adviser and spokesman. Within the framework of Creek government, his title was Itsi atcagagi thlucco (Great Beloved Man). Towns had many beloved men, respected advisors who sat on the sidelines. Being of the Wind clan, McGillivray could not be a mico, "but he could become a heniha if he became adept in his old age in the rituals of government and religion. A young man should not be a heniha, but a young man wise beyond his years might be a beloved man." 49.
54 Saunt, 83.
55 Kappler, 28.

already decided in error that Hippo Ilk Meco *is* Hopothle Mico, she compounds the mistake when she says Hopothle Mico was the Good Child King, not the Tallassee King.

Non-standard English spelling of Indian names complicates matters. The Indian names ascribed by Pope, *et al.*, to McGillivray were Hippo Ilk Meco or Hoboi Hili Miko. The Creek chief named Hopothle Mico was someone else. And the epithets help only if they are accurately assigned. Caughey states that McGillivray was called the Good Child King,[56] but Saunt and Green attribute the title of Good Child King to Hopothle Mico.[57] McGillivray was titled Great Beloved Man. Hopothle Mico was the Tallassee King, the son of the Old Tallassee King, and the Tame King. The epithets are confusing.

Place Names

Jaffe's mix-up of the two personal names continues with place names. She writes: "Since McGillivray lived in Little Tallassie, the epithet on Trumbull's drawing could be an error arising from the confusion of that name with Big Tallassie."[58]

Creek town and tribe names require more than a casual look as they are easily confused owing to the similar sounds, the recycling of names from place to place, and their misinterpretation by non-native speakers. Hopothle Mico was of Big Tallassee, a Creek town of the Upper Creeks on the eastern side of the Tallapoosa River, near present-day Tallassee, Alabama. McGillivray's home, also of the Upper Creeks, was at Little Tallassee, on the banks of the Coosa River, near present-day Wetumpka, Alabama. The spelling has many variations: Talassee, Talisi, Tallasee, Tallassee, Tallassie, Tallisee, Tulsa, etc. The place names were similar, but the places were not the same.

56 Caughey, 3.
57 Saunt, 79.; Green, *The Politics of Indian Removal: Creek Government and Society in Crisis* (Lincoln: University of Nebraska Press, 1985), 32.
58 Jaffe, 18.

The two locations were twenty to twenty-five miles apart.⁵⁹

Subjectivity

Jaffe's final argument relies on her interpretation of the written descriptions of McGillivray.⁶⁰ She points to the description by John Pope who commented that McGillivray looked like a gentleman of about forty-five years but at the time was only thirty-two. Pope noted that McGillivray's health was often poor and rendered his already delicate constitution "delicate and feeble." She also references Albert Pickett, who wrote without personal knowledge almost sixty years after McGillivray died about the peculiar shape of McGillivray's head and his mixed wardrobe of American and Indian dress. Jaffe thinks the visual evidence in the drawing and these descriptions support her theory.

Jaffe does not refer to an important contemporary description. On August 8, 1790, Abigail Adams wrote to her sister: "MacGillvery, dresses in our own fashion speaks English like a Native, & I should never suspect him to be of that Nation, as he is not very dark he is grave and solid, intelligent and much of a Gentleman, but in very bad Health."⁶¹ McGillivray's recurrent and documented health issues flared up at the time of the treaty, delayed negotiations, and probably prevented his participation in some of the festivities. He wrote on September 6, 1790: "Our

59 Amos J. Wright, Jr., *Historic Indian Towns of Alabama, 1540–1838* (Tuscaloosa: The University of Alabama Press, 2003); William A. Read, *Indian Place Names in Alabama*. Rev. ed. (Tuscaloosa: The University of Alabama Press, 1984); *Handbook of American Indians North of Mexico*, ed. by Frederick Webb Hodge (Smithsonian Institution, Bureau of American Indian Ethnology, 1930); 'Indian Villages and Forts of the Coosa-Tallapoosa River Region,' University of Alabama Cartographic Research Lab, http://alabamamaps.ua.edu/contemporarymaps/alabama/historical/villages.pdf.
60 Jaffe, 18.
61 Adams to Cranch.

journey to New York provd tedious & fatiguing, & was on my arrival there seized with a violent indisposition which held me a long time."[62]

As Joseph Ellis summarizes: "All descriptions of McGillivray that have survived agree on two points: he was very light-skinned, and he was physically unimpressive."[63]

Caughey goes further: "His health was persistently bad. His letters are interspersed with references to gout and rheumatism, splitting headaches, and confinement in bed for weeks on end." Venereal disease and other serious handicaps often left him weak and in great pain.[64]

The man in the drawing appears to be a healthy and robust Creek chief. He is not Alexander McGillivray. He is as the caption states—*Hopothle Mico, the Talasee King*.

Conclusion

At the beginning of her argument, Jaffe asks a two-part question: "Has Hopothle Mico come down to us in history under . . . the name of Alexander McGillivray . . . [or] . . . is this drawing in fact a portrait of Hopothle Mico?" While she finds for the former, the facts argue the latter.

Hopothle Mico and Alexander McGillivray were two different people. They had different names and were as a rule given different epithets. They were from different towns. They were contemporaries but political rivals. Both were in New York in 1790 and each signed the treaty.

Trumbull drew the likeness of Hopothle Mico and captioned the drawing with his name and the same epithet that he used on

62 Caughey, 279.
63 Ellis, 142.
64 Caughey, 3–4.

the treaty—Tallassee King—although the spellings are variations. Had he drawn McGillivray, he would have said so.

Alexander McGillivray was an important figure, famous in his own time, regarded as a celebrity, and featured in newspapers in the U.S. and abroad. Why did John Trumbull, who had his own celebrity and ego to feed, not draw the best-known Creek in the delegation and then brag about it? If he did draw McGillivray, would he not mention it in his autobiography with the other five drawings? Would he not have boldly captioned such a drawing with McGillivray's name? Trumbull's and McGillivray's silence on the matter and the lack of an extant sketch indicate that one never existed. We do not know why we have no drawing of McGillivray by Trumbull, but we can be confident that the drawing in question is not of him but is of Hopothle Mico, the Tallassee King.

The Question Remains

So many excellent portraits of the Indians were done that the absence of any likeness of the important McGillivray confounds us. How could a man with his resources and ego fail to leave us his image? How could someone from whom so many letters survive not have a surviving portrait? Caughey gives us a hint.

Manuscript materials on McGillivray survived primarily in four repositories in Seville, Madrid, Washington, and Berkeley, with a few others in Atlanta, Havana, Mexico City, Chicago, and New England. This tells us that these were the letters that McGillivray sent or are copies of letters sent to him. Where are the materials McGillivray had in his possession? None were ever found. Not by Albert Pickett. Not by Thomas McAdory Owen. Not by Caughey, who writes: "The presumption is that none exists."[65]

Just like his likeness.

65 Caughey, 365.

Bibliography

Adams, Abigail, Mary Smith Cranch and Stewart Mitchell. *New Letters of Abigail Adams*. Boston: Houghton Mifflin Co., 1947.
Adams, Abigail. The Adams Papers, Adams Family Correspondence. Vol. 9, January 1790–December 1793. C. James Taylor, et al. eds. Cambridge, MA: Harvard University Press, 2009: 84–86. http://founders.archives.gov/documents/Adams/04-09-02-0046. Accessed August 2013.
American State Papers. Indians Affairs. Washington.
Bauer, William J., Jr. Introduction to *McGillivray of the Creeks*, by John Walton Caughey. Columbia: University of South Carolina Press, 2007.
Buchanan, John H. Email to LMC. 22 Aug. 2013.
Caughey, John Walton. *McGillivray of the Creeks*. Norman: University of Oklahoma Press, 1938.
Cooper, Helen, A. et al. *John Trumbull: The Hand and Spirit of a Painter*. New Haven: Yale University Art Gallery, Distributed by Yale University Press, 1982.
Debo, Angie. *The Road to Disappearance: A History of the Creek Indians*. Norman: University of Oklahoma Press, 1967.
Doster, James F. *The Creek Indians and their Florida lands, 1740–1823*. New York: Garland, 1974.
Ellis, Joseph. *American Creation: Triumphs and Tragedies at the Founding of the Republic*, New York: Random House, 2007.
Fordham University. Digital Collections.
Foreman, Carolyn Thomas. "Alexander McGillivray, Emperor of the Creeks." *Chronicles of Oklahoma* 7, no. 1 (March, 1929):

106–120. http://digital.library.okstate.edu/chronicles/v007/v007p106.html. Accessed August 2013.

Frank, Andrew K. "Alexander McGillivray." *Encyclopedia of Alabama*. Published May 28, 2009. Last updated June 27, 2013. http://www.encyclopediaofalabama.org/face/Article.jsp?id=h-2313. Accessed August 2013.

Frick Collection. http://research.frick.org

Fundaburk, Emma Lila. *Southeastern Indians Life Portraits: A Catalogue of Pictures 1564–1860*. Luverne, AL: 1958.

———. *Southeastern Indians Life Portraits: A Catalogue of Pictures 1564–1860*. Tuscaloosa, AL: University of Alabama Press: 2000.

Green, Michael. "Alexander McGillivray." *American Indian Leaders: Studies in Diversity*. Ed. Russell David Edmunds. Lincoln: University of Nebraska Press, 1980.

———. *The Politics of Indian Removal: Creek Government and Society in Crisis*. Lincoln: University of Nebraska Press, 1985.

Handbook of American Indians North of Mexico. Frederick Webb Hodge, ed. Smithsonian Institution, Bureau of American Indian Ethnology, 1930.

Hawkins, Benjamin. *Creek Confederacy and a Sketch of the Creek Country*. Savannah: 1848.

Hendrix, Tom. Interviewed for expertise on Indian dress and adornments.

Jaffe, Irma B. *John Trumbull, Patriot-Artist of the American Revolution*. Boston: New York Graphic Society, 1975.

———. "Fordham University's Mistaken Identities in 'The Declaration of Independence' and Other Discoveries." *American Art Journal* 3 (Spring 1971): 5–38.

Kappler, Charles J., comp. and ed. *Indian Affairs: Laws and Treaties*. Washington: Government Printing Office, 1904.

Knight, Vernon J. Letter to author, April 18, 2014.

Langley, Linda. "The Tribal Identity of Alexander McGillivray: A

Review of the Historical and Ethnographic Data." *Louisiana History* 46 (Spring 2005): 231–39.

Morgan, John Hill. *Paintings by John Trumbull at Yale University of historic scenes and personages prominent in the American Revolution.* New Haven: Pub. for the Associates in Fine Arts at Yale University by the Yale University Press, 1926.

Munn, Charles Allen. *Three Types of Washington Portraits: John Trumbull, Charles Wilson Peale, Gilbert Stuart.* New York: The Gilliss Press, 1908.

Nash, Gary. "The Forgotten Experience." In *The American Revolution: Changing Perspectives.* William M. Fowler, Jr. and Wallace Coyle, eds. Boston: Northeastern University Press, 1979: 31–46.

National Archives and Records Administration. *Founders Online.* http://founders.archives.gov.

New York Public Library. Digital Collections.

Paterek, Josephine. *Encyclopedia of American Indian Costume.* New York: W. W. Norton & Company, 1996.

Read, William A. *Indian Place Names in Alabama.* Rev. ed. Tuscaloosa: The University of Alabama Press, 1984.

Richardson, Edgar P. "A Penetrating Characterization of Washington by John Trumbull." *Winterthur Portfolio* 3, 1967. Chicago: The University of Chicago Press: 1–23.

Roberts, Gary. "The Chief of State and the Chief." *American Heritage* 26, no.6, 1975.

Saunt, Claudio. *A New Order of Things: Property, Power, and the Transformation of the Creek Indians, 1733–1816.* Cambridge: Cambridge University Press, 1999.

Sizer, Theodore. *The Works of Colonel John Trumbull, Artist of the American Revolution.* New Haven: Yale University Press, 1967.

Smithsonian Institution. Digital Collections.

Stiggins, George. *Creek Indian History: A Historical Narrative of the Genealogy, Traditions and Downfall of the Ispocoga or Creek Indian*

Tribe of Indians by One of the Tribe. William Stokes Wyman, intro and notes, Virginia Pounds Brown, ed. Birmingham: Birmingham Public Library Press, 1989.

Swanton, John R. *The Indians of the Southeastern United States*. Smithsonian Institution Bureau of American Ethnology Bulletin 137. Washington: GPO, 1946.

_____. *Social Organization and Social Usages of the Indians of the Creek Confederacy*. Smithsonian Institution Bureau of American Ethnology. 42nd Annual Report. Washington: GPO, 1928, 23–472.

Trumbull, John. *The Autobiography, Reminiscences and Letters of John Trumbull from 1756 to 1841 1756–1841*. New Haven: B. L. Hamlen, 1841.

Trumbull, John. *The Autobiography of Colonel John Trumbull, Patriot-Artist, 1756–1843*. Edited by Theodore Sizer. New Haven: Yale University Press, 1953.

University of Alabama. Cartographic Research Lab. [Map] "Indian Villages and Forts of the Coosa-Tallapoosa River Region." http://alabamamaps.ua.edu/contemporarymaps/alabama/historical/villages.pdf. Accessed Sept. 2013.

Walker, William. "Creek Confederacy Before Removal." In *Handbook of North American Indians*. Vol. 14, Southeast. Raymond Fogelson and William C. Sturtevant, eds. U.S. Government Printing Office, 2004: 373–392

Washington, George. *The Papers of George Washington: Presidential Series*. Dorothy Twohig and W. W. Abbot, eds. Charlottesville: University Press of Virginia, 1987– .

Washington, George. *The Diaries of George Washington*. Donald Jackson and Dorothy Twohig, eds. Charlottesville: University Press of Virginia, 1976–1979.

Willett, William M. *A Narrative of the Military Actions of Colonel Marinus Willett, Taken Chiefly from his own Manuscript, Prepared

by his Son William M. Willett. New York: Carvill, 1831.
Wright, Amos J., Jr. *Historic Indian Towns of Alabama, 1540–1838.* Tuscaloosa: The University of Alabama Press, 2003.
Wright, J. Leitch, Jr. "Creek American Treaty of 1790: Alexander McGillivray and the Diplomacy of the Old Southwest." *The Georgia Historical Quarterly* 51 (December 1967): 379–400.

With Gratitude

The authors relied on many pairs of eyes to see this paper to publication and many hands to guide it into the world. We thank everyone who helped us and who stayed with the effort that began ten years before it ended.

Laurella Owens, who deciphered the interesting handwriting of her friend, pieced the fragments of her thoughts into phrases and sentences, and maybe even read her mind.

Benjamin Cohen, who earned a merit badge for research, explained the inexplicable, and was able to offer criticism like it was a present.

John "I go by Jack" Buchanan, who gave two very bold thumbs-up to us to set the record straight on the image of Hopothle Mico.

At Yale University, Dr. Helen Cooper who read the original paper and posed questions that we had not asked, much less answered.

At Fordham University, Patrice Kane, head of Archives and Special Collections, whose swift and accurate service to provide images and permissions should set the standard for the task.

At the City of New York, Julianna Monjeau, manager of Archives & Special Collections, Public Design Commission, whose efficiency and courtesy proved once again why we love New York.

At Yale University, the staff who never, ever gave up looking and then delivered handsomely: David Whaples, Visual Resources Coordinator; George Miles, William Robertson Coe Curator, Yale Collection of Western Americana, Beinecke Rare Book &

Manuscript Library; and June Can, MLIS, Access Services, Beinecke Rare Book and Manuscript Library.

At the Smithsonian Institution, the staff who made rummaging in our nation's attic easy: Adam Minakowski, Reference Archivist, National Anthropological Archives, and Daisy Njoku, Anthropology Archives & Collections, National Museum of Natural History.

At Winterthur Museum, Dr. Catharine Dann Roeber, Curatorial Fellow, and Susan Newton, Coordinator, Photo Services, who endured persistent (pesky) email and remained cordial in the face of great whining.

At the National Archives, Mary Frances Ronan, Archival Operations, who knew exactly what we needed and where we could find it, and like all good librarians, gave us more than one route to get there.

At NewSouth Books, Suzanne LaRosa, who with each plea for patience became ever more virtuous.

www.ingramcontent.com/pod-product-compliance
Lightning Source LLC
Chambersburg PA
CBHW021042180526
45163CB00005B/2243